The Hebridean Desk Address Book

Illustrations by Mairi Hedderwick

· Lunga · Treshnish · Bac Mòr ·

BIRLINN

This edition first published in 2011 by
Birlinn Limited
West Newington House
10 Newington Road
Edinburgh
EH9 1QS

www.birlinn.co.uk

ISBN: 978 1 84158 987 9

British Library Cataloguing-in-Publication Data
A Catalogue record for this book is available from the British Library

Printed in China

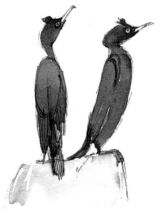

These Hebridean sketches have been garnered over a period of forty years – some whilst living on one of the islands, others as I escaped from mainland exile. Some landmarks are no more – a post box disappeared, the old pier superseded by the new, many hens long gone into the pot. The mountains and headlands and the horizon line of the sea, however, never change – or diminish. And neither do the midges.

— Mairi Hedderwick

Name

Address

Telephone

Email

Name

Address

Telephone

Email

Name

Address

Telephone

Email

Name

Address

Telephone

Email

Name

Address

Telephone

Email

Name

Address

Telephone

Email

· Staffin · Skye ·

Name

Address

Telephone

Email

Name

Address

Telephone

Email

Name

Address

Telephone

Email

Name

Address

Telephone

Email

Name

Address

Telephone

Email

Name

Address

Telephone

Email

Name

Address

Telephone

Email

Name

Address

Telephone

Email

Name

Address

Telephone

Email

Name

Address

Telephone

Email

Name

Address

Telephone

Email

Name

Address

Telephone

Email

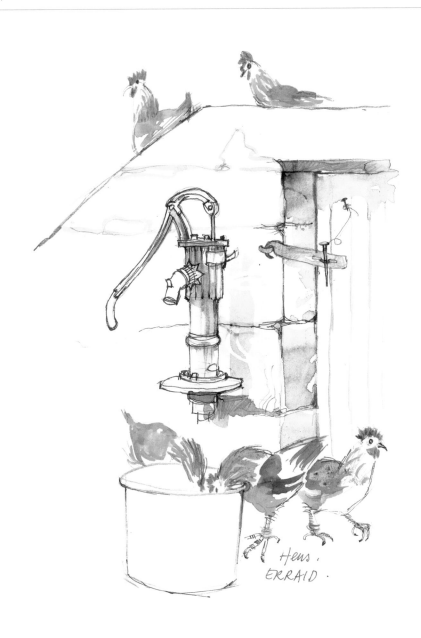

Hens.
ERRAID.

Name

Address

Telephone

Email

Name

Address

Telephone

Email

Name

Address

Telephone

Email

Name

Address

Telephone

Email

Name

Address

Telephone

Email

Name

Address

Telephone

Email

Name

Address

Telephone

Email

Name

Address

Telephone

Email

Name

Address

Telephone

Email

Name

Address

Telephone

Email

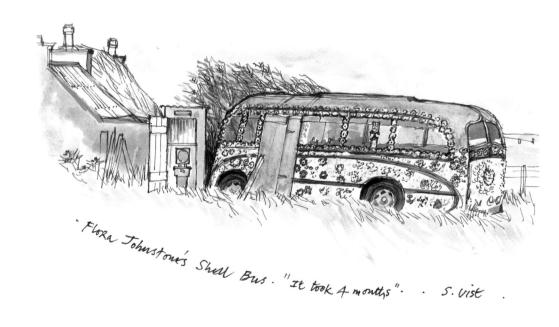

"Flora Johnstone's Shell Bus. "It took 4 months". . S. Vist .

Name

Address

C

Telephone

Email

Name

Address

Telephone

Email

Name

Address

Telephone

Email

Name

Address

Telephone

Email

Name

Address

Telephone

Email

Name

Address

Telephone

Email

Name

Address

Telephone

Email

Name

Address

Telephone

Email

Name

Address

Telephone

Email

Name

Address

Telephone

Email

Name

Address

Telephone

Email

Name

Address

Telephone

Email

Name

Address

Telephone

Email

Name

Address

Telephone

Email

Name

Address

Telephone

Email

Name

Address

Telephone

Email

Name

Address

Telephone

Email

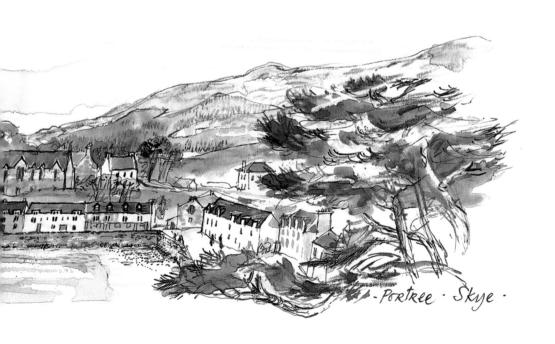

· Portree · Skye ·

Name

Address

Telephone

Email

Name

Address

Telephone

Email

Name

Address

Telephone

Email

Name

Address

Telephone

Email

Name

Address

Telephone

Email

Name

Address

Telephone

Email

Name

Address

Telephone

Email

Name

Address

Telephone

Email

Name

Address

Telephone

Email

Name

Address

Telephone

Email

Name

Address

Telephone

Email

Name

Address

Telephone

Email

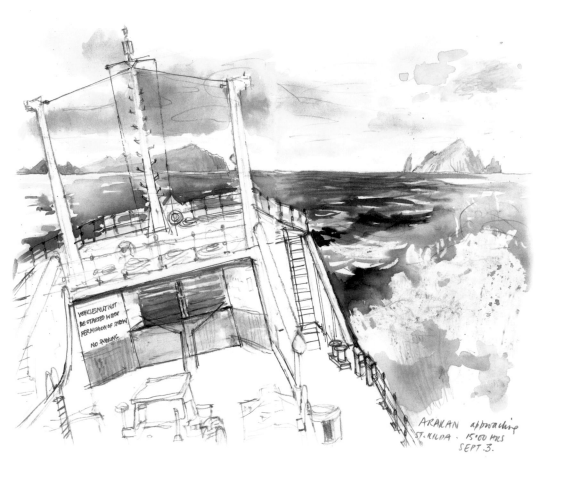

ARAKAN approaching
ST. KILDA · 15·00 HRS
SEPT.3.

Name

Address

Telephone

Email

Name

Address

Telephone

Email

Name

Address

Telephone

Email

Name

Address

Telephone

Email

Name

Address

Telephone

Email

Name

Address

Telephone

Email

Name

Address

Telephone

Email

Name

Address

Telephone

Email

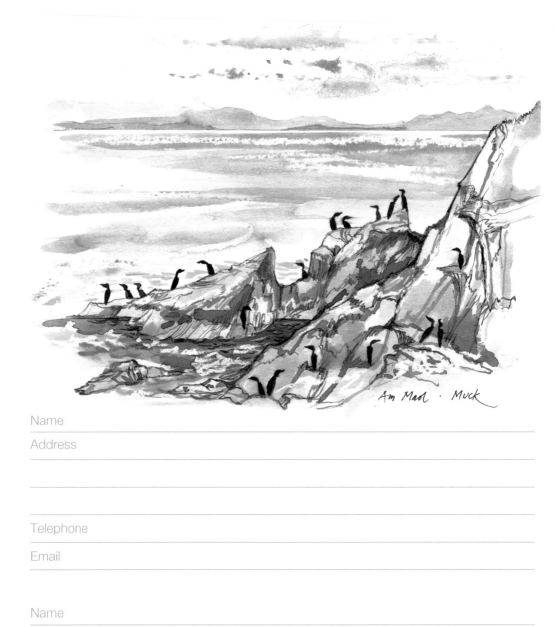

Am Maol · Muck

Name

Address

Telephone

Email

Name

Address

Telephone

Email

Name

Address

Telephone

Email

E

Name

Address

Telephone

Email

Name

Address

Telephone

Email

Name

Address

Telephone

Email

Name

Address

Telephone

Email

Name

Address

Telephone

Email

Name

Address

Telephone

Email

Name

Address

Telephone

Email

Name

Address

Telephone

Email

E

Name

Address

Telephone

Email

Name

Address

Telephone

Email

Name

Address

Telephone

Email

Name

Address

Telephone

Email

Name

Address

Telephone

Email

Name

Address

Telephone

Email

Name

Address

Telephone

Email

Name

Address

Telephone

Email

F

Name

Address

Telephone

Email

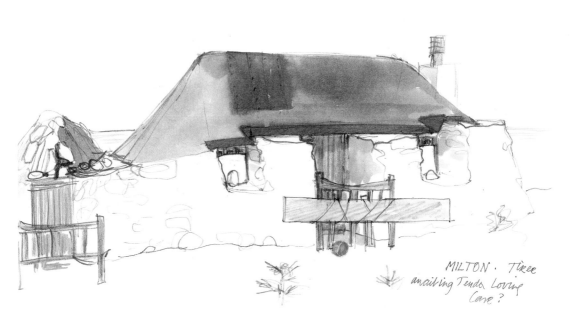

MILTON · Tiree
awaiting Tender Loving
Care?

Name

Address

Telephone

Email

Name

Address

Telephone

Email

Name

Address

Telephone

Email

Name

Address

Telephone

Email

Name

Address

Telephone

Email

F

Name

Address

Telephone

Email

Name

Address

Telephone

Email

Name

Address

Telephone

Email

Name

Address

Telephone

Email

Name

Address

Telephone

Email

Name

Address

Telephone

Email

Name

Address

Telephone

Email

G

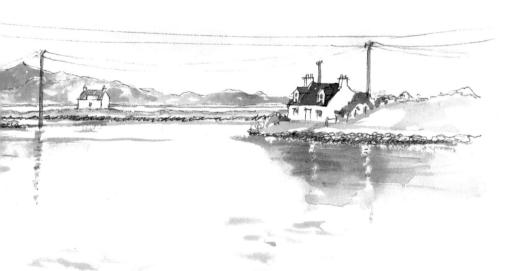

· Lachie's crannog · Grimsay ·

Name

Address

Telephone

Email

Name

Address

Telephone

Email

Name

Address

Telephone

Email

Name

Address

Telephone

Email

Name

Address

Telephone

Email

Name

Address

Telephone

Email

Name

Address

Telephone

Email

Name

Address

Telephone

Email

Name

Address

Telephone

Email

Name

Address

Telephone

Email

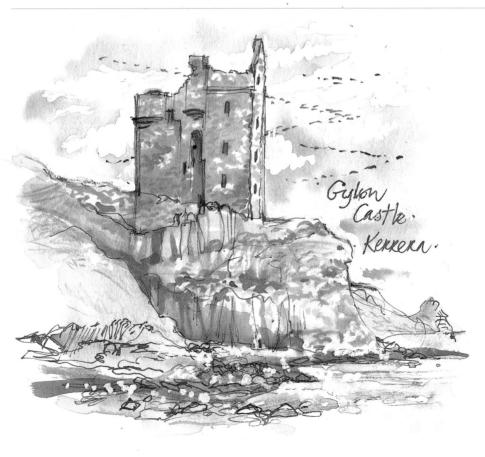

Gylen
Castle.
Kerrera.

Name

Address

Telephone

Email

Name

Address

Telephone

Email

Name

Address

Telephone

Email

Name

Address

Telephone

Email

Name

Address

Telephone

Email

Name

Address

Telephone

Email

Name

Address

Telephone

Email

Name

Address

Telephone

Email

Name

Address

Telephone

Email

Name

Address

Telephone

Email

Name

Address

Telephone

Email

Name

Address

Telephone

Email

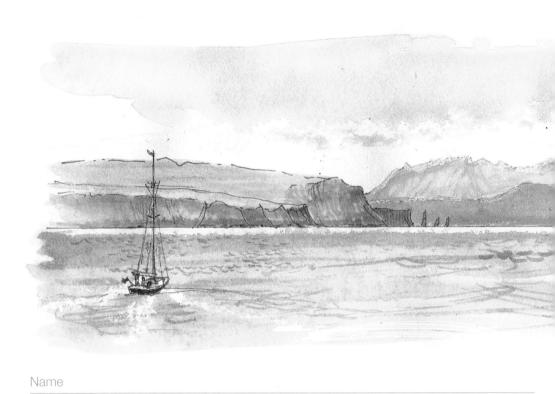

Name

Address

Telephone

Email

Name

Address

Telephone

Email

Leaving Canna
Cuillins behind

Name

Address

Telephone

Email

Name

Address

Telephone

Email

Name

Address

Telephone

Email

Name

Address

Telephone

Email

Name

Address

Telephone

Email

Name

Address

Telephone

Email

Name

Address

Telephone

Email

Name

Address

Telephone

Email

Name

Address

Telephone

Email

Name

Address

Telephone

Email

Name

Address

Telephone

Email

Name

Address

Telephone

Email

Name

Address

Telephone

Email

Name

Address

Telephone

Email

Name

Address

Telephone

Email

Name

Address

Telephone

Email

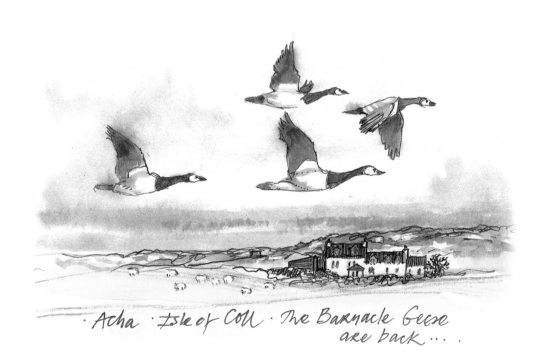

· Acha · Isle of Coll · The Barnacle Geese
are back · · · ·

Name

Address

Telephone

Email

Name

Address

Telephone

Email

Name

Address

Telephone

Email

Name

Address

Telephone

Email

Name

Address

Telephone

Email

Name

Address

Telephone

Email

Name

Address

Telephone

Email

Name

Address

Telephone

Email

Name

Address

Telephone

Email

Name

Address

Telephone

Email

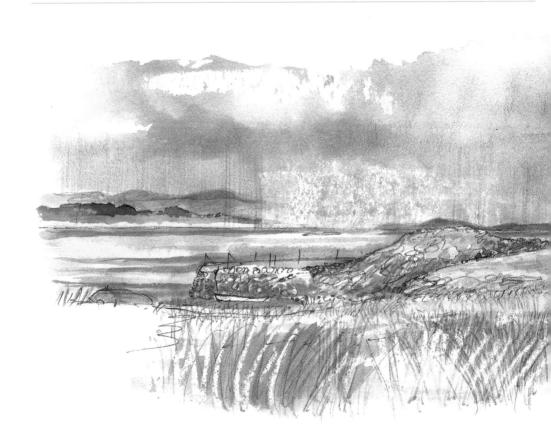

Name

Address

Telephone

Email

Name

Address

Telephone

Email

K

Grass Point · Lochdon · MULL

Name

Address

Telephone

Email

Name

Address

Telephone

Email

Name

Address

Telephone

Email

Name

Address

Telephone

Email

Name

Address

Telephone

Email

Name

Address

Telephone

Email

K

Name

Address

Telephone

Email

Name

Address

Telephone

Email

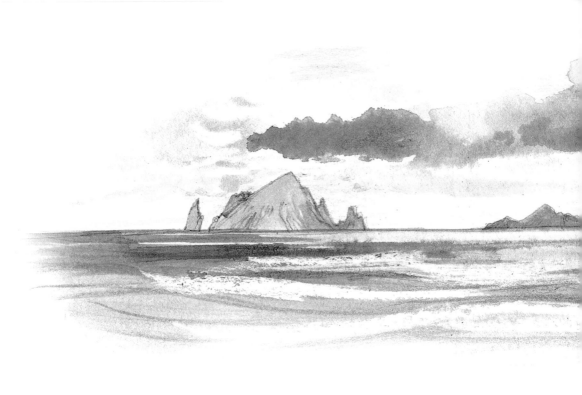

Name

Address

Telephone

Email

Name

Address

Telephone

Email

- St. Kilda Group -

Name

Address

Telephone

Email

Name

Address

Telephone

Email

Name

Address

Telephone

Email

Name

Address

Telephone

Email

Name

Address

Telephone

Email

Name

Address

Telephone

Email

Name

Address

Telephone

Email

Name

Address

Telephone

Email

L

Name

Address

Telephone

Email

Name

Address

Telephone

Email

Name

Address

Telephone

Email

Name

Address

Telephone

Email

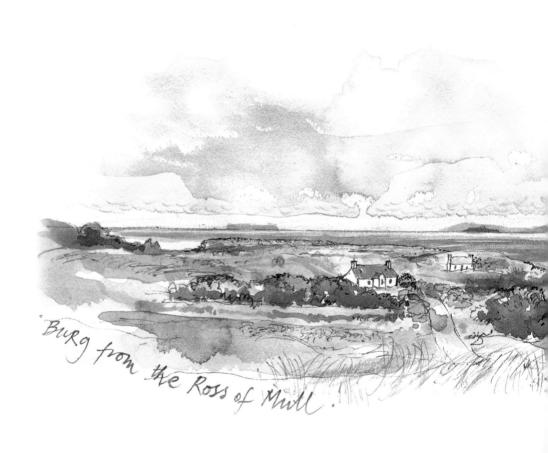

"Burg from the Ross of Mull."

Name

Address

Telephone

Email

Name

Address

Telephone

Email

M

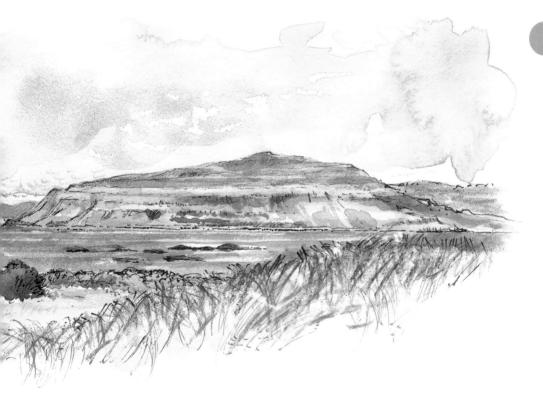

Name

Address

Telephone

Email

Name

Address

Telephone

Email

Name

Address

Telephone

Email

Name

Address

Telephone

Email

Name

Address

Telephone

Email

Name

Address

Telephone

Email

Name

M

Address

Telephone

Email

Name

Address

Telephone

Email

Name

Address

Telephone

Email

Name

Address

Telephone

Email

Name

Address

Telephone

Email

Name

Address

Telephone

Email

Name

Address

Telephone

Email

Name

Address

Telephone

Email

Name

Address

Telephone

Email

Name

Address

Telephone

Email

Name

Address

Telephone

Email

Name

Address

Telephone

Email

Name

Address

Telephone

Email

Name

Address

Telephone

Email

Name

Address

Telephone

Email

Name

Address

Telephone

Email

Name

Address

Telephone

Email

M

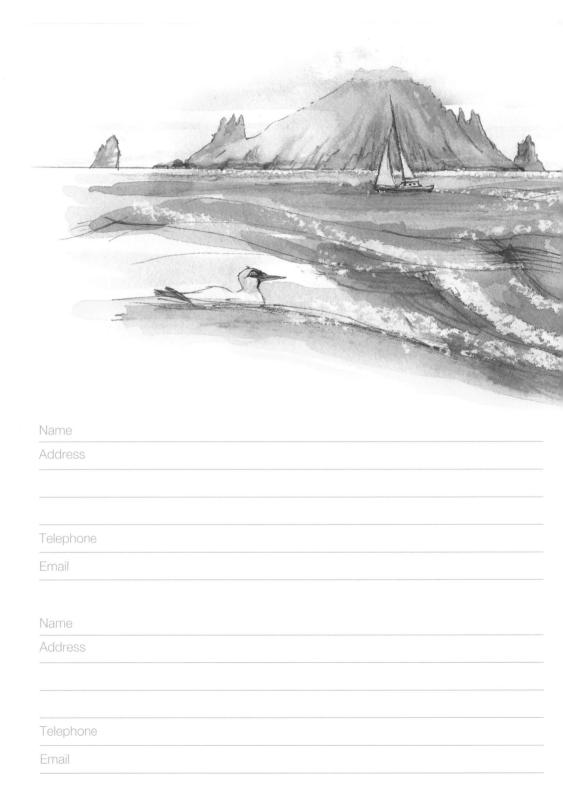

Name

Address

Telephone

Email

Name

Address

Telephone

Email

Kylebhan approaching Boreray.

St. Kilda Trip

Name

Address

Telephone

Email

N

Name

Address

Telephone

Email

Name

Address

Telephone

Email

Name

Address

Telephone

Email

Name

Address

Telephone

Email

Name

Address

Telephone

Email

Name

Address

Telephone

Email

Name

Address

Telephone

Email

Name

Address

N

Telephone

Email

Name

Address

Telephone

Email

Name

Address

Telephone

Email

Name

Address

Telephone

Email

Name

Address

Telephone

Email

Name

Address

Telephone

Email

Name

Address

Telephone

Email

Name

Address

Telephone

Email

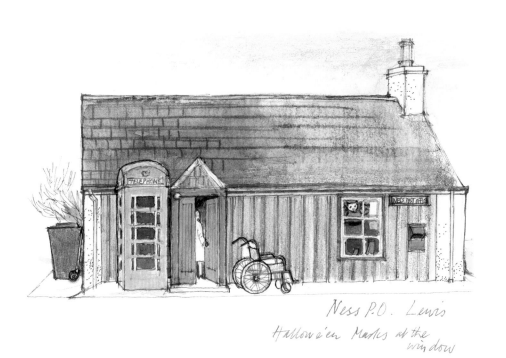

Ness P.O. Lewis
Hallowe'en Masks at the window

Name

Address

Telephone

Email

Name

Address

Telephone

Email

Name

Address

Telephone

Email

Name

Address

Telephone

Email

Name

Address

Telephone

Email

Name

Address

Telephone

Email

Name

Address

Telephone

Email

O

Name

Address

Telephone

Email

Name
Address

Telephone
Email

Name
Address

Telephone
Email

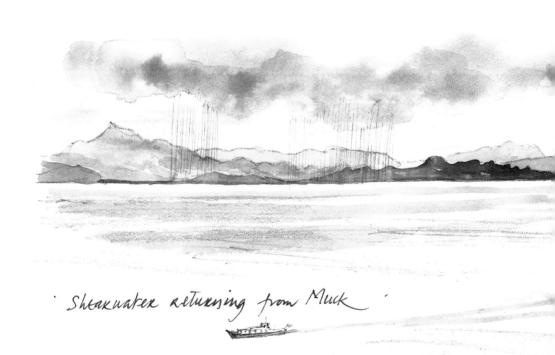

Sheawater returning from Muck

Name

Address

Telephone

Email

Name

Address

Telephone

Email

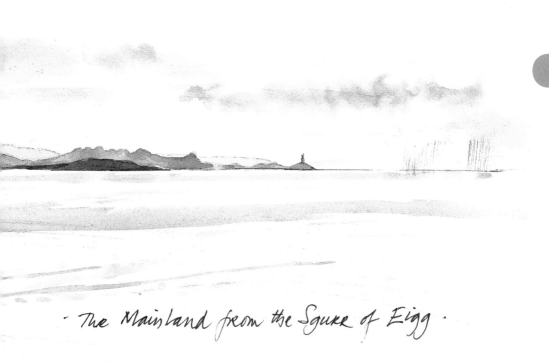

· The Mainland from the Sgurr of Eigg ·

Name

Address

Telephone

Email

Name

Address

Telephone

Email

Name

Address

Telephone

Email

Name

Address

Telephone

Email

Name

Address

Telephone

Email

Name

Address

Telephone

Email

Name

Address

Telephone

Email

Name

Address

Telephone

Email

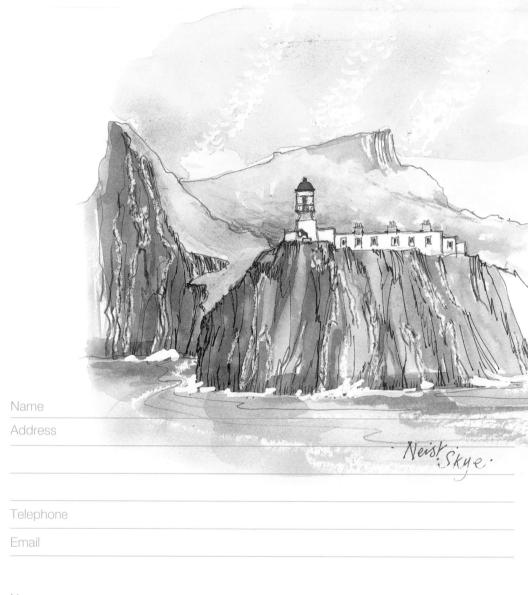

Neist Skye.

Name

Address

Telephone

Email

Name

Address

Telephone

Email

Name

Address

Telephone

Email

Name

Address

Telephone

Email

Name

Address

Telephone

Email

PQ

Name

Address

Telephone

Email

Name

Address

Telephone

Email

Name

Address

Telephone

Email

Name

Address

Telephone

Email

Name

Address

Telephone

Email

Name

Address

Telephone

Email

Name

Address

Telephone

Email

Name

Address

Telephone

Email

R

Name

Address

Telephone

Email

Name

Address

Telephone

Email

Name

Address

Telephone

Email

Name

Address

Telephone

Email

Name

Address

Telephone

Email

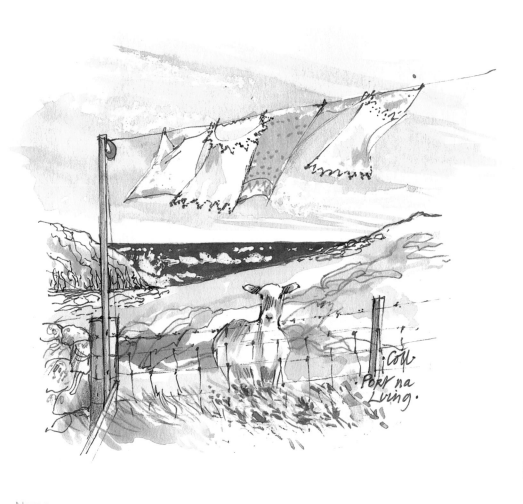

Coll
Port na
Luing.

Name

Address

Telephone

Email

Name

Address

Telephone

Email

Name

Address

Telephone

Email

Name

Address

Telephone

Email

Name

Address

Telephone

Email

Name

Address

Telephone

Email

Name

Address

Telephone

Email

Name

Address

Telephone

Email

R

Name

Address

Telephone

Email

Name

Address

Telephone

Email

Name

Address

Telephone

Email

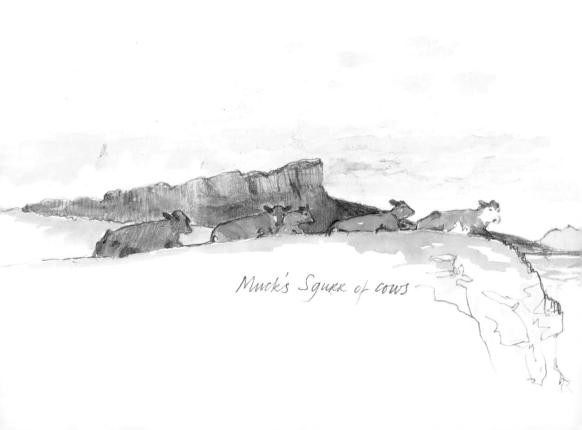

Muck's Squrr of cows

Name

Address

Telephone

Email

Name

Address

Telephone

Email

Name

Address

Telephone

Email

Name

Address

Telephone

Email

S

Name

Address

Telephone

Email

Name

Address

Telephone

Email

Name

Address

Telephone

Email

Name

Address

Telephone

Email

Name

Address

Telephone

Email

Name

Address

Telephone

Email

Name

Address

Telephone

Email

S

Name

Address

Telephone

Email

Name

Address

Telephone

Email

Name

Address

Telephone

Email

Name

Address

Telephone

Email

Name

Address

Telephone

Email

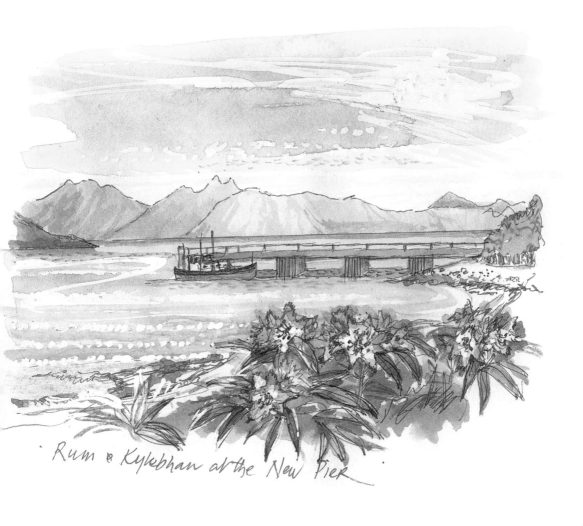

Rum & Kylebhan at the New Pier

Name

Address

Telephone

Email

Name

Address

Telephone

Email

Name

Address

Telephone

Email

Name

Address

Telephone

Email

Name

Address

Telephone

Email

Name

Address

Telephone

Email

Name

Address

Telephone

Email

Name

Address

Telephone

Email

S

Name

Address

Telephone

Email

Name

Address

Telephone

Email

Name

Address

Telephone

Email

Name

Address

Telephone

Email

Tires

Name

Address

Telephone

Email

Name

Address

Telephone

Email

Name

Address

Telephone

Email

Name

Address

T

Telephone

Email

Name

Address

Telephone

Email

Name

Address

Telephone

Email

Name

Address

Telephone

Email

Name

Address

Telephone

Email

Name

Address

Telephone

Email

Name

Address

Telephone

Email

Name

Address

Telephone

Email

Name

Address

Telephone

Email

T

Name

Address

Telephone

Email

Name

Address

Telephone

Email

Name

Address

Telephone

Email

Name

Address

Telephone

Email

Name

Address

Telephone

Email

NORTHBAY

BARRA

SATURDAY is a bad day to start anything....

T

Name

Address

Telephone

Email

Name

Address

Telephone

Email

Name

Address

Telephone

Email

Name

Address

Telephone

Email

Name

Address

Telephone

Email

Name

Address

Telephone

Email

Name

Address

Telephone

Email

Name

Address

UV

Telephone

Email

Name

Address

Telephone

Email

Name

Address

Telephone

Email

Name

Address

Telephone

Email

Name

Address

Telephone

Email

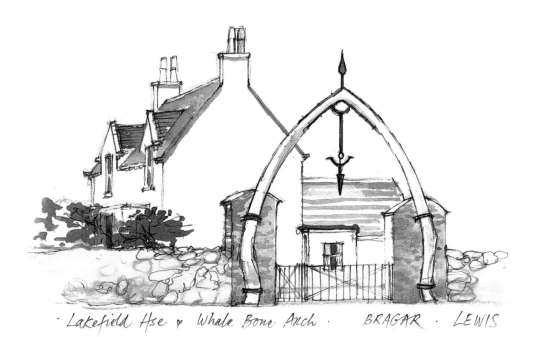

· Lakefield Hse & Whale Bone Arch · BRAGAR · LEWIS

Name

Address

Telephone

Email

Name

Address

Telephone

Email

UV

Name

Address

Telephone

Email

Name

Address

Telephone

Email

Name

Address

Telephone

Email

Name

Address

Telephone

Email

Name

Address

Telephone

Email

Name

Address

Telephone

Email

Name

Address

Telephone

Email

Name

Address

W

Telephone

Email

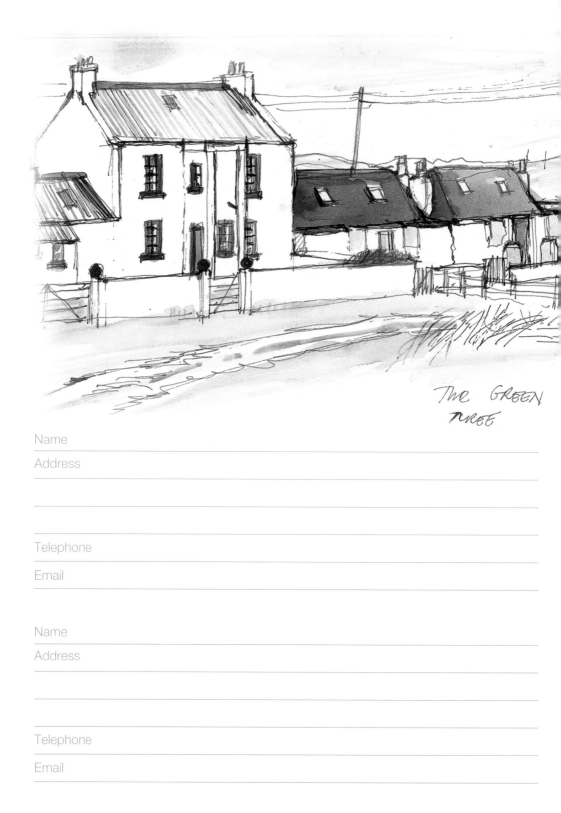

THE GREEN
TIREE

Name

Address

Telephone

Email

Name

Address

Telephone

Email

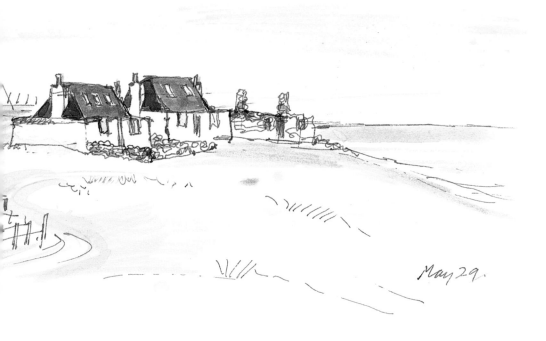

May 29.

Name

Address

Telephone

Email

Name

Address

Telephone

Email

W

Name

Address

Telephone

Email

Name

Address

Telephone

Email

Name

Address

Telephone

Email

Name

Address

Telephone

Email

Name

Address

Telephone

Email

Name

Address

Telephone

Email

Name

Address

Telephone

Email

Name

Address

W

Telephone

Email

Name

Address

Telephone

Email

Name

Address

Telephone

Email

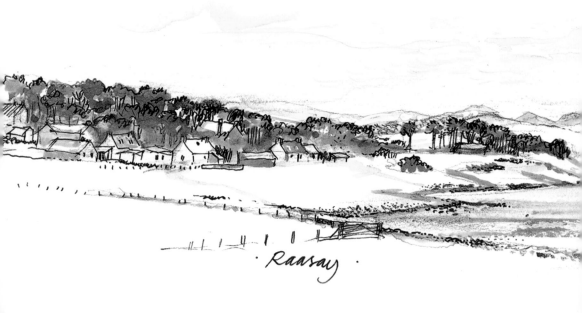

. Raasay .

Name

Address

Telephone

Email

Name

Address

Telephone

Email

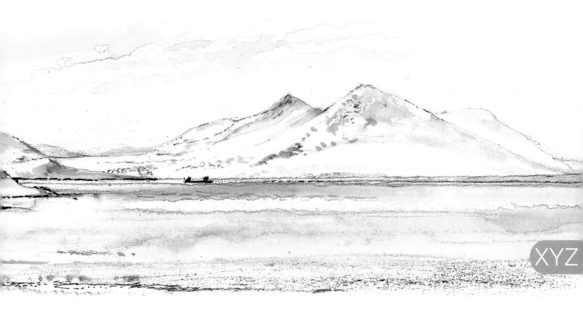

XYZ

Name

Address

Telephone

Email

Name

Address

Telephone

Email

Name

Address

Telephone

Email

Name

Address

Telephone

Email

Name

Address

Telephone

Email

Name

Address

Telephone

Email

Name

Address

Telephone

Email

Name

Address

Telephone

Email

XYZ

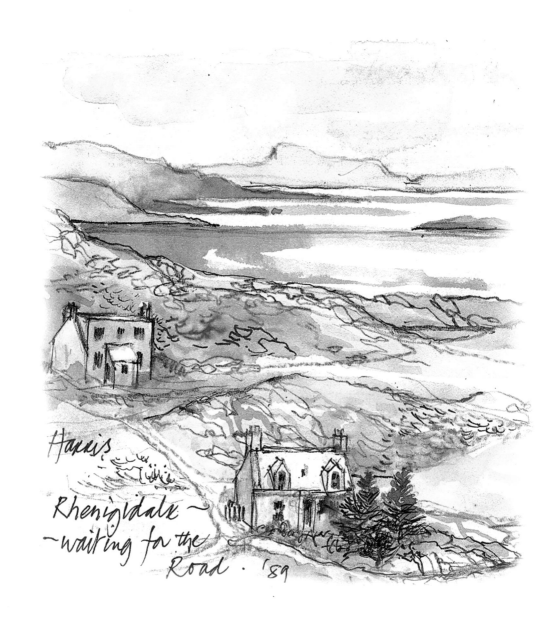

Harris

Rhenigidale ~
~waiting for the
Road · '89